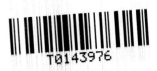
T0143976

SAMMY'S BLANKET

By Judi Rambo-Lividini

Dedication

To- Paula Wager my art instructor and friend who believed in me before I believed in myself.

To- all my children Johnny, Lisa, Heather, Tory, and grandchildren Kendal, Jake, & Owen

Book Designer: Diana Seciu

To order additional copies of this book, contact:
Xlibris
1-888-795-4274
www.Xlibris.com
Orders@Xlibris.com

Print information available on the last page.

Rev. date: 09/24/2019

BIOGRAPHY

Judi Rambo-Lividini was born and grew up in Royal Oak, Michigan. Her father the late Mr. E. Y. Rambo was a beloved sixth grade teacher in the Royal Oak area. At an early age Judi's father taught her to love books and art. She started drawing in the fourth grade. Mostly self taught she works in colored pencil, watercolors and oils. Judi has worked for over twenty years in Early Childhood Education in the Commerce, West Bloomfield area. Judi and Sammy now live in Hartland, Michigan.

INFORMATION

If you would like to order additional books please check out the web site WWW.XLIBRIS.COM

If you would like to have Sammy make a personal appearance for a book signing at your school, library, or bookstore, please call Judi's School of Fine Arts at 810.632.9906 and leave a message..

Hello! My name is Sammy. I'm a hairless dog. Yes, you heard me right – NO HAIR! Well, I do have a little on my head, paws, and tail. So you can understand why I <u>NEED</u> my blanket. You can't? Well, you see, other dogs have hair on their bodies. It helps to keep them warm, right? I don't have any hair to keep me warm. That's why I <u>NEED</u> my blanket.

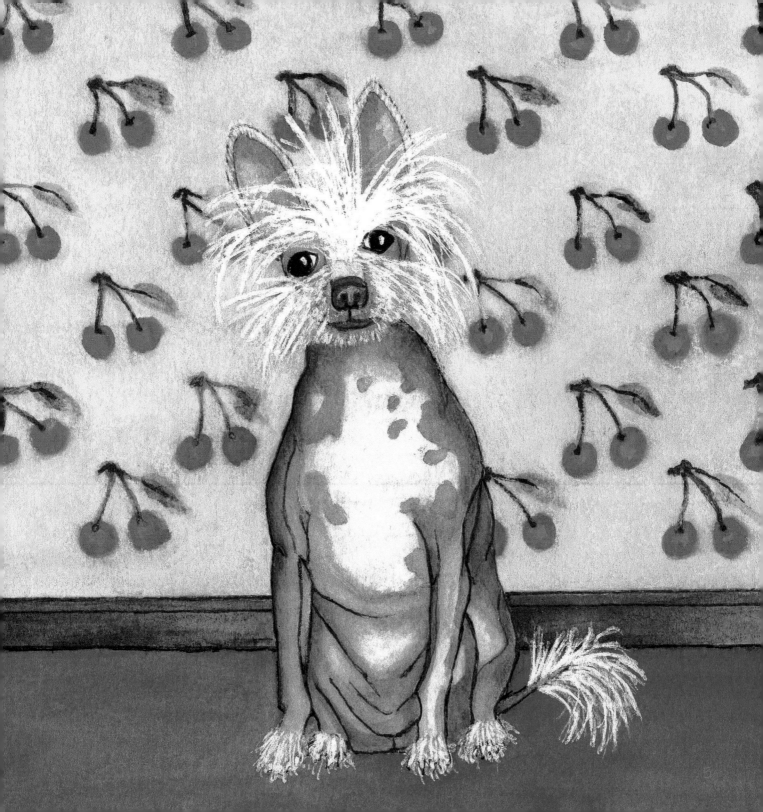

Let me tell you what happened one night. I was sound asleep, dreaming that I was rolling around on the soft grass, enjoying a warm sunny day.

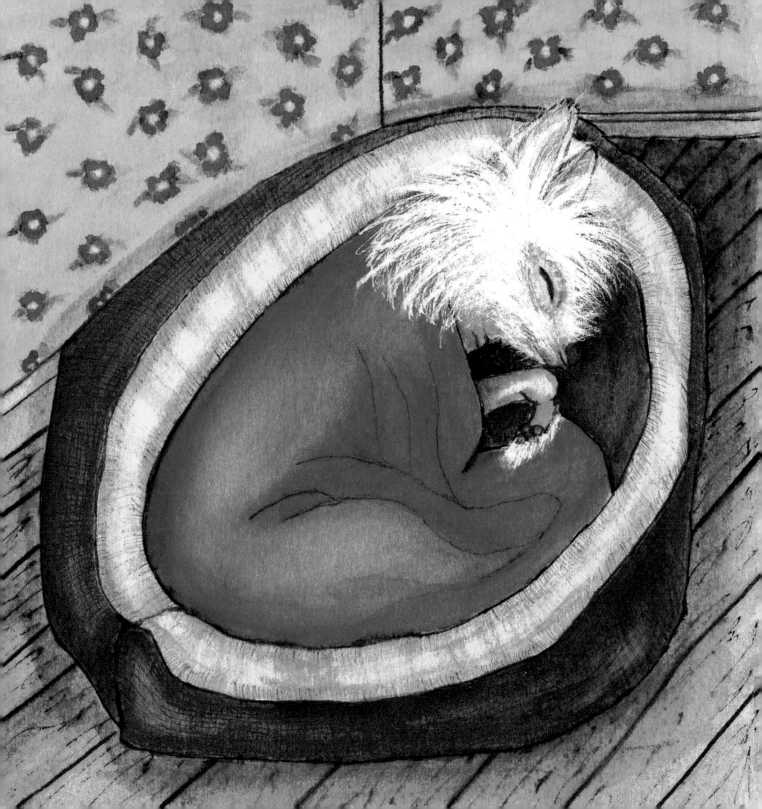

Then, all of a sudden it started to snow. I became
very, very cold. Freeeeee-zing cold.
I woke up. I was in my bed.
My blanket was gone.
WHERE'S MY BLANKET?!

Oh me, oh my
Oh bow-wow, boo-hoo.
What am I going to do?

I looked everywhere for my blanket. I could not
find it anywhere.

Oh me, oh my
Oh bow-wow, boo-hoo.
What am I going to do?

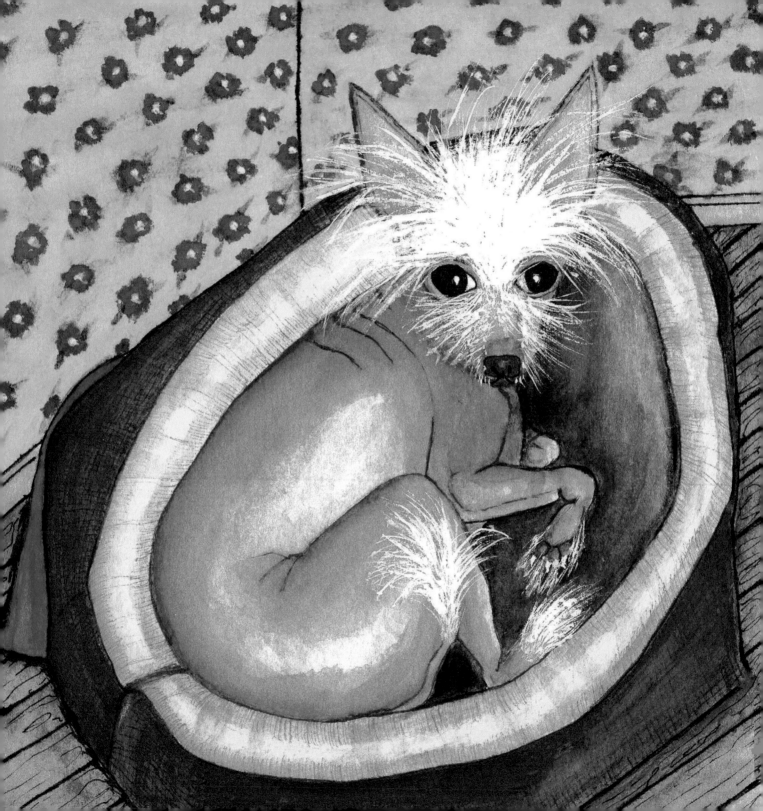

I know! I have an idea! I will try to find something to wear, something in place of my blanket. Maybe that will help keep me warm, snuggly, and cuddly.

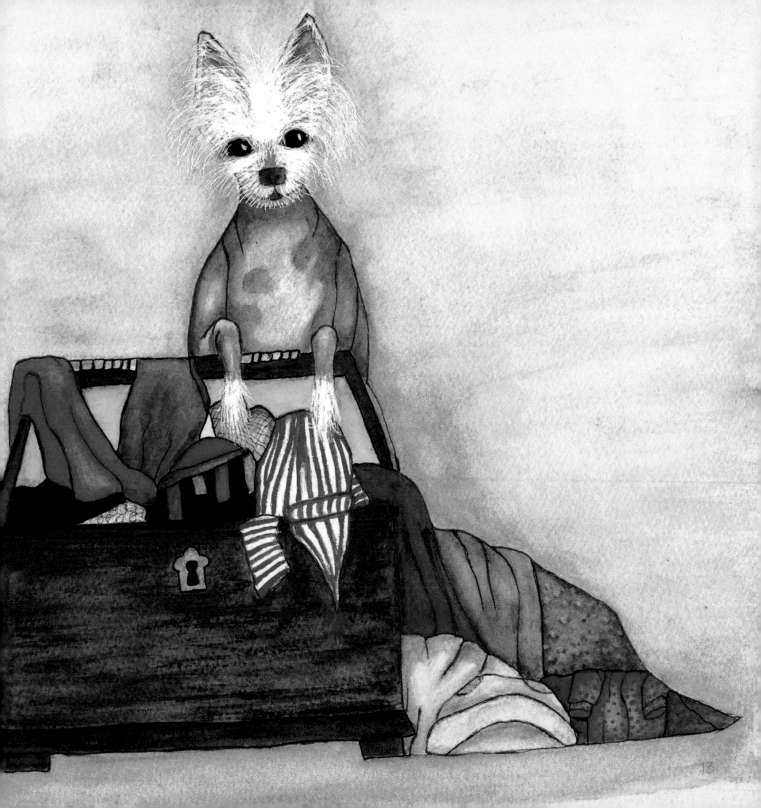

Let's see..........Will this black leather jacket be better than my warm, Snuggly, Cuddly, Blanket?

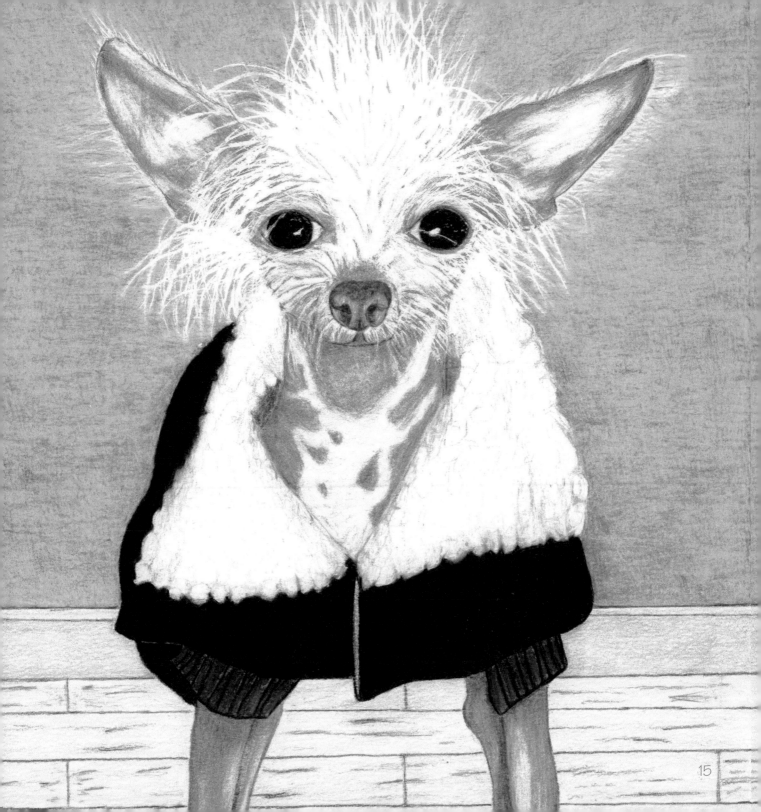

No I don't think so.
Leather makes too
much noise it will
keep me awake.

Squeak, Squeak

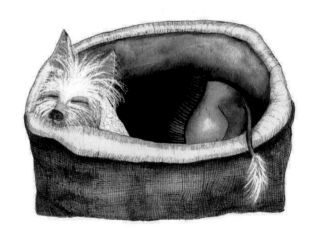

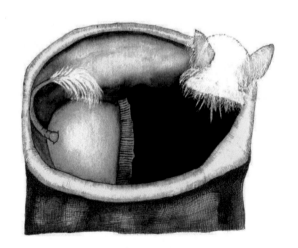

Crinkle, crinkle Squeak, squeak

What about this nightgown and cap, will that be better than my warm, Snuggly, Cuddly, Blanket?

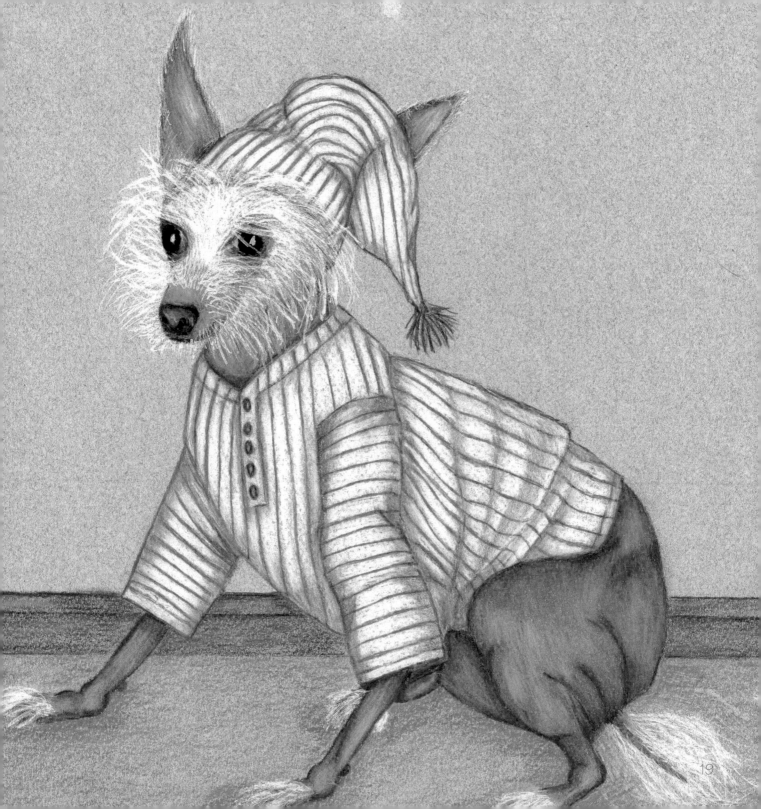

No I don't think so. My front end will be warm but my backside will not.

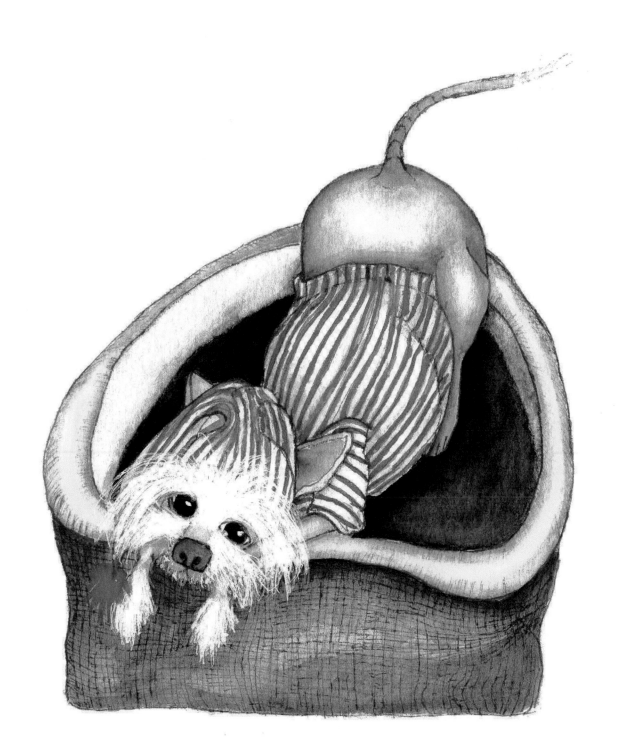

Will this snow jacket be better than my warm,
Snuggly, Cuddly, Blanket?

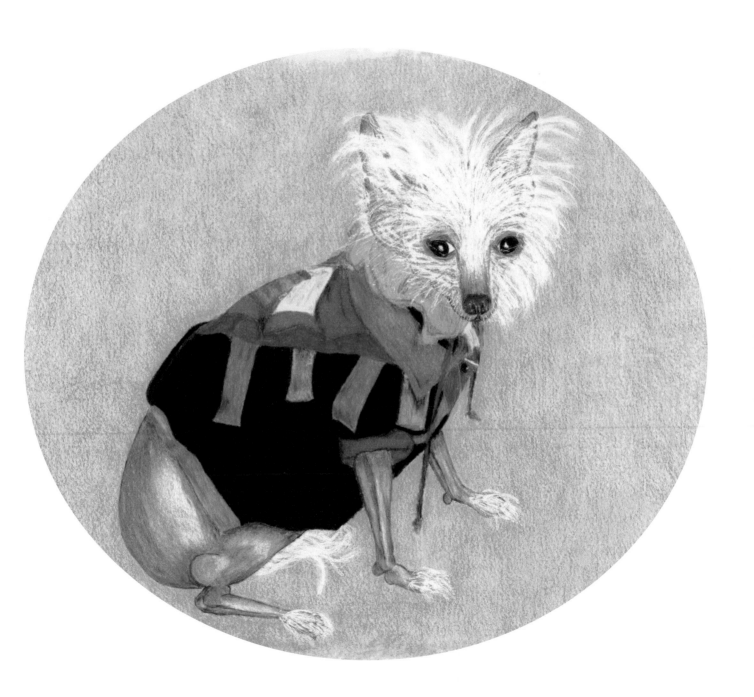

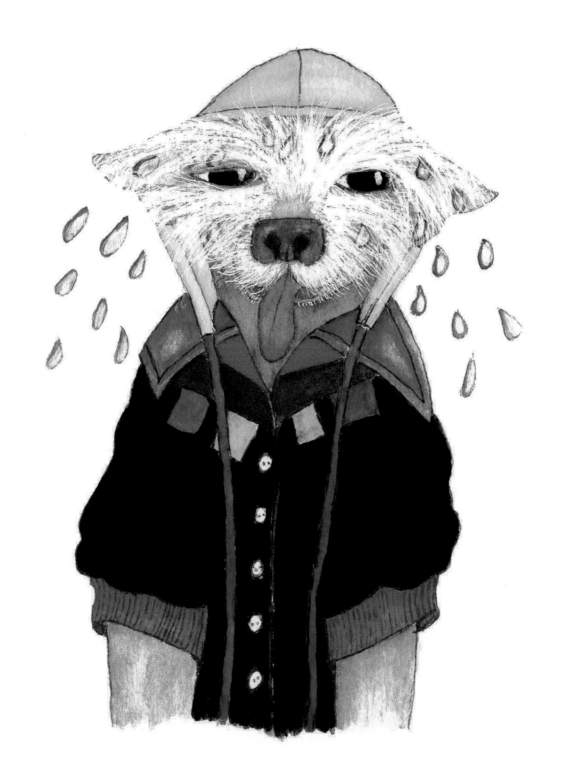

This raincoat and rain hat will be better than my warm, Snuggly, Cuddly, Blanket right?

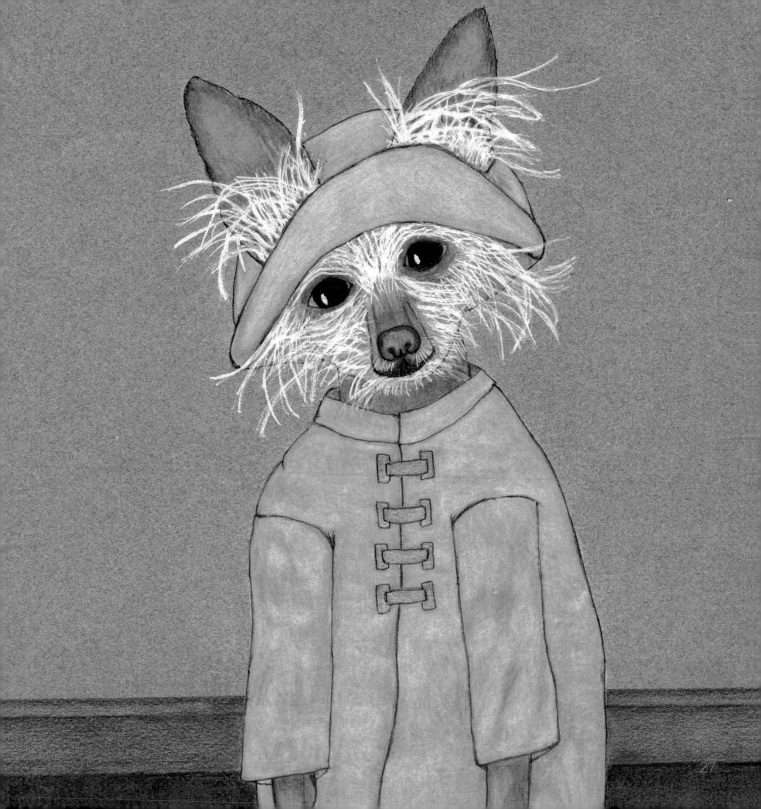

No I don't think so. My raincoat is too stiff.
I will not be able to curl up with my paws under
my chin.

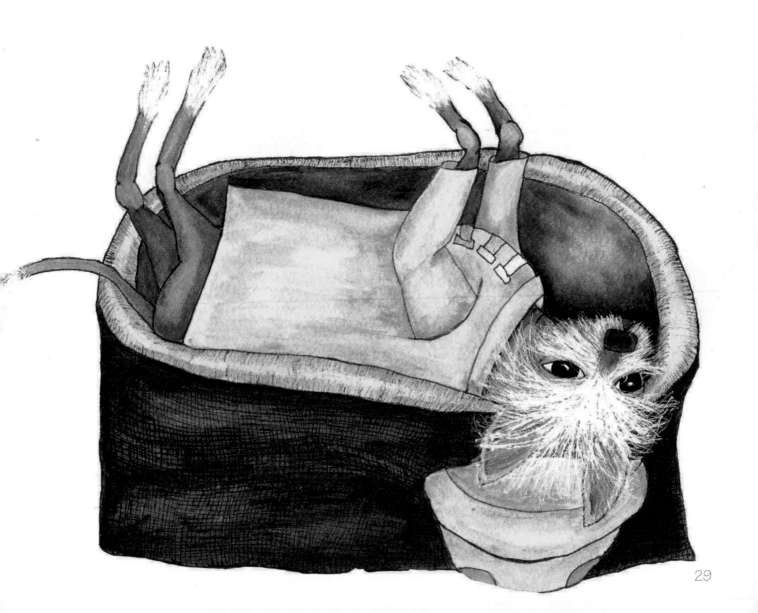

How about these superdog P J's will they be better than my warm,
Snuggly, Cuddly, Blanket?

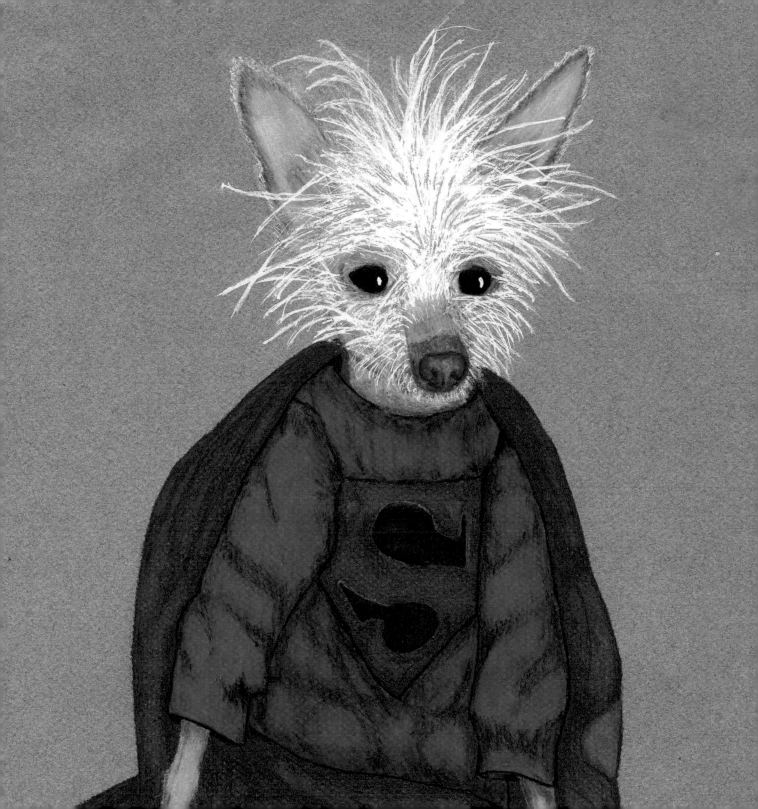

No I don't think so. My cape will tangle around my head, get caught on my ears then how would I get out of bed?

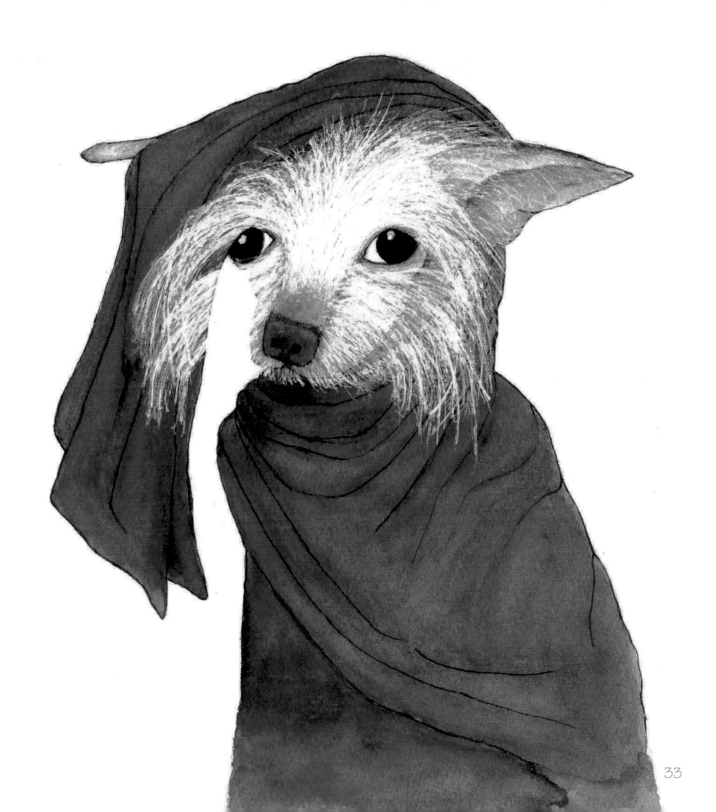

Oh…me, oh my,
Oh, bow – wow, boo – hoo.
What am I going to do?

Nothing seems to work. What am I going to do?
I'm so sad, so very, very sad.

WHERE'S MY BLANKET?!

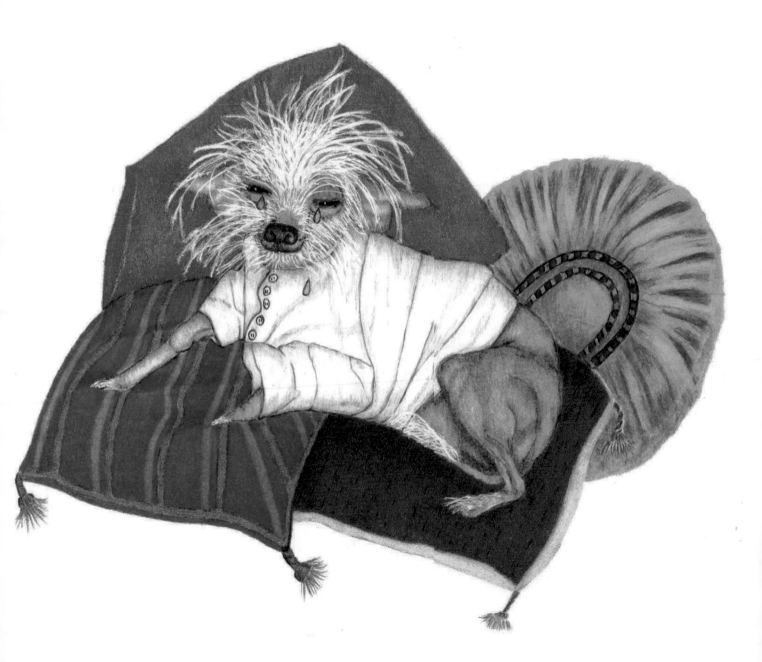

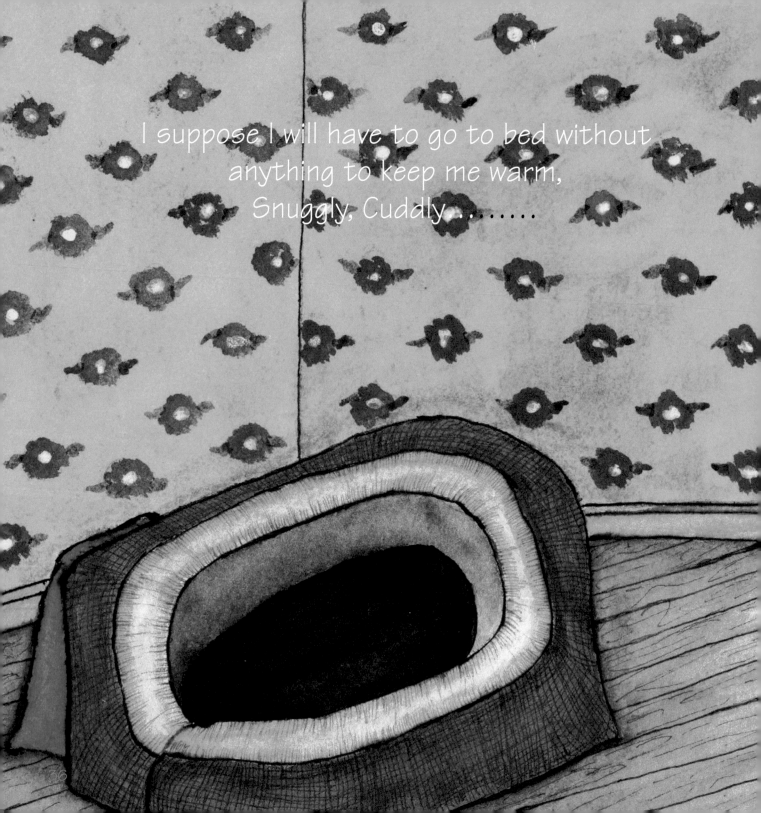

I suppose I will have to go to bed without
anything to keep me warm,
Snuggly, Cuddly.........

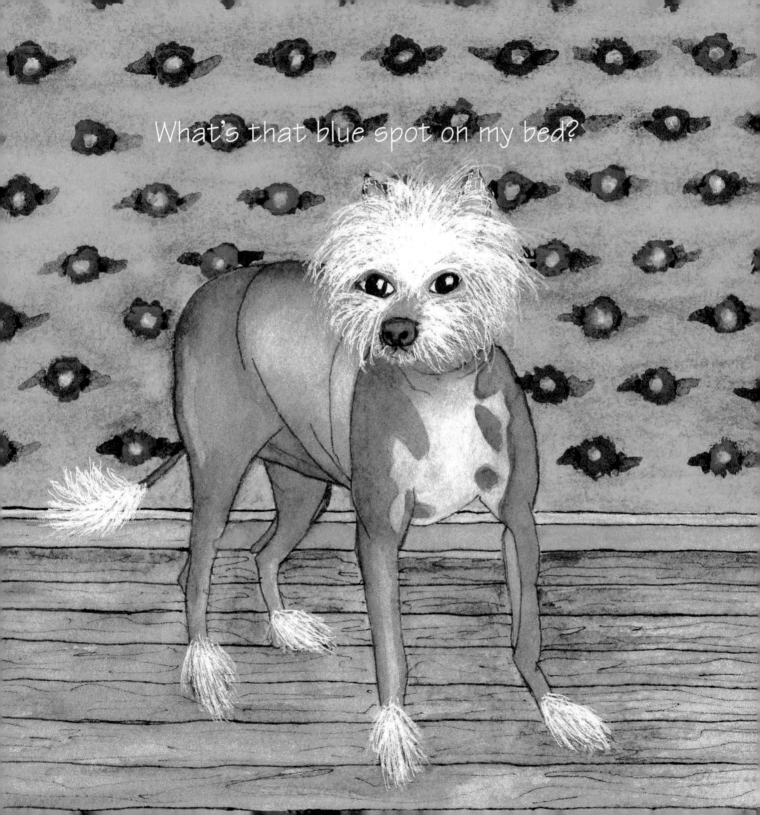

What's that blue spot on my bed?

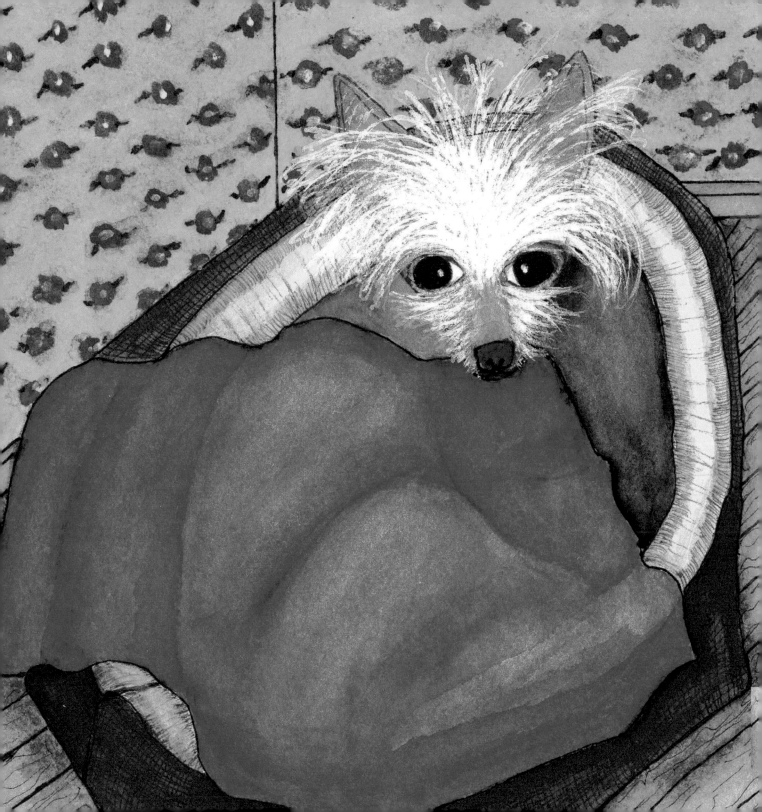

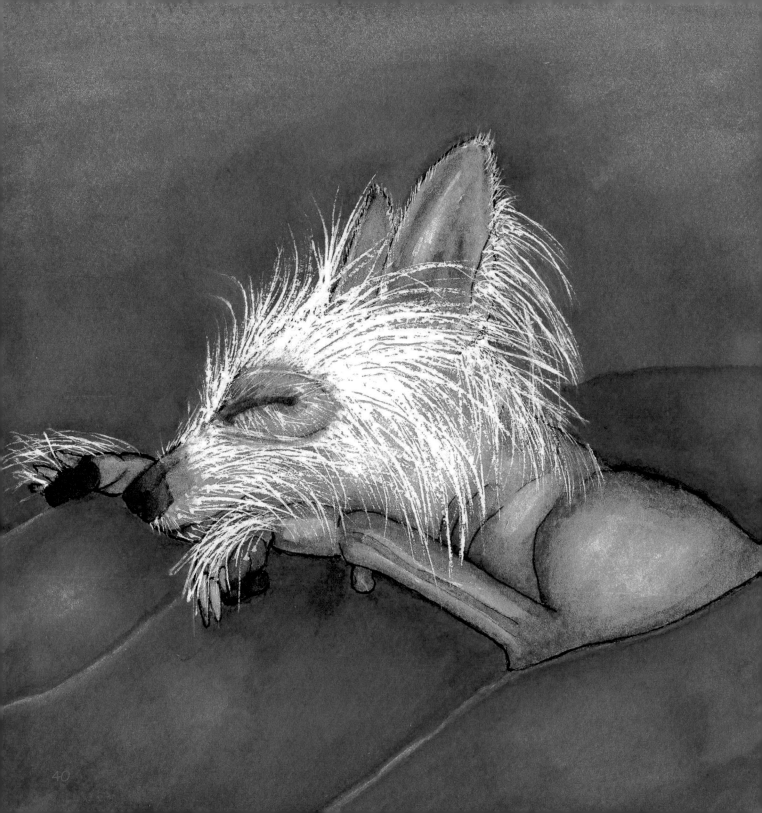

Good night